MW00785300

PETALS

NICK KARRAS

Foreword & Interview by
Carol Pharo

Design by
Jesse Karras

Crystal River Publishing

To place an order, go to www.PetalsTheJourney.com

ISBN 978-0-9743562-6-6

Acknowledgements

Thanks first to my Father for letting me into his magical darkroom at age ten. Next to my Mother who, when she found out recently that I was creating this book, asked the penetrating question, "Why do you need to do this?" Cautionary words truly worth pondering.

I had the special pleasure of working with my son Jesse Karras on this and other projects. His computer graphic and design skills have contributed greatly in the presentation of my photographic work.

Along the way, I was helped in a variety of ways by my close friends Bruce Dyer, Robin Dyer, Arnie Carter, Loretta Warner, Bob Hahn M.D., Lynn Hahn, and Carol Pharo. Professional guidance came from Sarah Hans, Linda Savage, Richard Carrington,

Denise Castelli and Ashley Aimes of Class Films and Philip Hitchcock in Britain gave my vision an international audience. I was invigorated with the good-natured assistance of Maria Blanchard, Trish Maxwell, Jennifer Ramsey, and Claudine Hassler. A special mention must be given to Beck Peacock. From the very beginning, he helped to shape this project with his talent as a writer, editor, and visual artist. Most important, he was a candid and dependable friend during the many times when I most needed one.

Finally, to the many vibrant and confident women who chose to reveal themselves in this book, I am honored and humbled by the trust you have shown in me.

Foreword

by Carol Pharo

"Petals is a joyful journey through a vulva garden of delights."
- Betty Dodson, legendary artist, author, and teacher

Petals is a book of vulvas, their exquisite beauty and wondrous variety. The photography unfolding here is a candid presentation of the most essential part of the female anatomy, an unyielding mystery shrouded in cultural taboos. The subtle black and white photographs, accented by light and shadow, display the delicate shapes and textures of female genitals, inspiring a profound sense of wonder and awe.

The subject has long been taboo. If this book were simply about rendering art, reactions to it would be a less complicated matter. But historically cultures in every part of the world—whether driven by religious beliefs based on mythological fears or in male-dominated societies — are confused about the physical functions and powers of women. They have often turned female organs into a thing of dread. Through the centuries cultures have made the biological realities of the female body into a mind- numbing labyrinth of customs and laws. The result has been a network of cruel practices that have effectively controlled the minds and imaginations of girls and boys, men and women.

In many traditions women have been segregated and often demonized for the innate functions of their vulvas. Menstruation, for example, was a very mysterious process to ancient peoples. Bleeding, associated with wounds, led to confusion and fear. In Islam and Judaism, having sex with menstruating women is forbidden. Menstruation was viewed as involving the unholy elimination of bloody bodily wastes. This primitive thinking then concluded that menstruating woman were "unclean." Our grim Puritan heritage applied these distorted views to the very nature of female sexuality. It's understandable that women under such cultural influences would develop negative feelings about this defining part of their body.

However there has always been another view. The sensuous female form has forever been the focus of artists. Sculptors, painters, and finally photographers have attempted to capture the essence of women's sensuality by uncovering their bodies with brushes, tools, and the click of a camera.

"You can't mistake the loving attention that went into the making of Petals, a form of goddess worship" writes the Canadian art critic Robert Amos. The ancients were the first to be drawn to the cardinal nature of the vulva. Dr. Linda Savage, author of Reclaiming Goddess Sexuality, observes, "The first god was actually a goddess. Because what people saw was this miracle of giving birth. What we understand as best we can is that they honored erotic energy from a spiritual perspective, it's ability to bring us closer to union with source".

Looking closely at Mayan sculptures, Roman frescos, Chinese scroll painting, Japanese Shunga drawings, Indian temple carvings, one is struck by the amazing number and kinds of representations of female genitalia. The modern works of artists such as Georgia O'Keeffe have carried this theme on to canvas.

The photographs disclosed in Petals give yet another dimension to this tradition. Karras boldly adds the art of photography with the wonderful variety of genital configurations, dispelling the myth of a single standard for judging their beauty. Clearly showing the reality of a woman's vulva, free of sexist undertones and judgment, is the key. The artistic objectivity Karras brings to these pictures—all shot from the same angle, the same light qualities, developed with the same graphic textures—allows the viewer to finally see vulvas in all their diversities. Internationally acclaimed art critic A.D. Coleman notes, "Nick Karras has approached the subject with very near a botanist's eye for the variety of this particular physical form." Indeed, Petals seems to a most appropriate title for the book.

It's when the issues concerning the vulva move from a cultural level to personal ones that the impact of sexual self-worth hits home. Stifled female sexual self-esteem is regularly begun with a mistaken perception of her genitals. Deep-seated negative beliefs very often directly and indirectly affect a woman's sense of sexual self worth. Sarah Mundy ran an educational website called All About My Vagina. " I got tons of email from women who are very upset, often in secret. They try to ignore it, but they really get depressed when

they think their vagina is ugly or deformed."

Dr. Debby Herbenick with The Kinsey Institute for Research in Sex, Gender and Reproduction backs this up, "Individuals may adopt negative attitudes toward women's genitals as a result of cultural-level scripts. There's this focus on women's genitals and how they look. Many people attribute the shift to the proliferation of hard-core pornography, in which vulvas have been standardized uniformly shaped."

In one study she asked women and men to respond to questions about the beauty of female genitals. Men were generally more positive than women, a point that didn't surprise her. "Men are more relaxed and open and accepting of women's genitals. Women assume the worst, they're anxious. Men are just happy to be invited to the party." Current marketing campaigns have swung away from hygiene and now focus largely on appearance and the growing popularity of female genital cosmetic surgery. Thousands of women of every age are buying into a serious surgical procedure motivated by cultural and aesthetic ignorance. Yet the plastic surgery industry ignores the damaged psychology that drives a woman to make labia-plasty its fourth most administered cosmetic procedure. The issue here is vital to women's mental and physical health. Under the outdated pretext of proper sexual discussion, the major media remains properly quiet.

There seems to be a variety of reasons for it. Unfortunately, almost all women have inherited large parts of the destructive myths of the past. Such flawed attitudes can have a direct impact on a woman's acceptance of sexual pleasure. Studies show that while receiving cunnilingus, women who have positive feelings about the appearance of their genitalia find it much easier to climax. Whether learned from a church's desire to control, from a mother's awkward explanations, from the media's uncanny ability to misinterpret and misinform, from a lover's sexual ignorance, or personal inexperience with one's own vulva, a woman's sexual self-percept is hazardous territory.

Lucid common sense about vulvas is rarely given to young women. Everything gravitates toward self doubt, and following that, a negative self image. It takes a conscious effort to awaken a person to a positive sexual self-esteem. Sayaka Adachi, a practicing sexologist in San Diego, says it simply, "We look at all kinds of different faces, there are all kinds of

different hands, and we appreciate a range of eye colors, eye shapes and noses. But we rarely really think about our genitals as something beautiful, something to be proud of".

Adding to this sentiment, Betty Dodson, long an advocate for women's self knowledge, talks about these pictures with her usual frankness, "First women will say, 'Oh, they're all different.' And then they will start to look at the interesting variations, and pretty soon they'll start to identify their own. So now they know that they fit into a range of beautiful. You go to the garden, you look at the flowers. You don't expect them to all look alike!" Realizing that simple fact has changed women's lives.

Change, both culturally and personally, is happening. Women in North America and around the world have taken to the streets to boldly proclaim their "Pussy Power". This is not only a political slogan but also a shouting out of pride in their essential woman-ness. The now unveiled secrecy surrounding the vulva is at the center of women's most current political liberation. Acknowledgment and respect for the sexual essence of womanhood is revolutionary! Bringing this kind of basic enlightenment to women of all ages is the primary motivation of this book. Petals was created to be fully enjoyed on every level of awareness. There is nothing about the source of our humanity that is not worthy of knowing. These photographs honor the vulva as the wellspring of life.

Dedicated to the truly enchanting women
who grace these pages with their sacred beauty

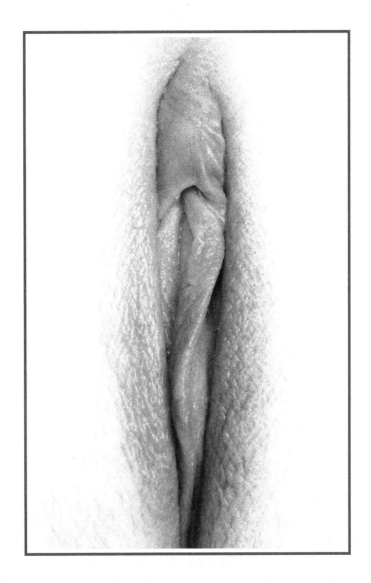

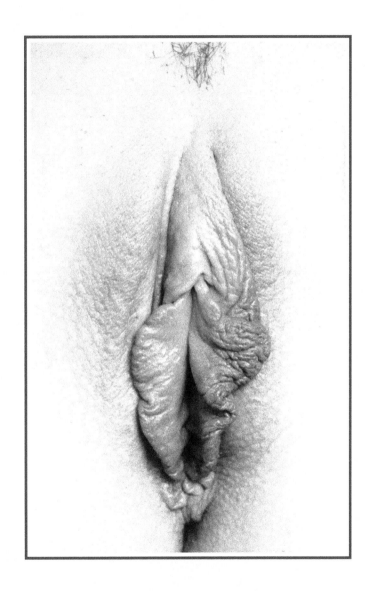

11

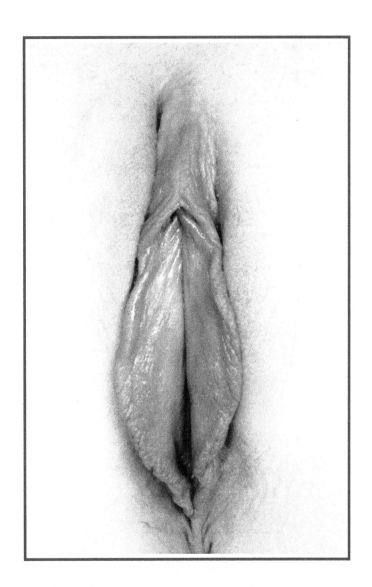

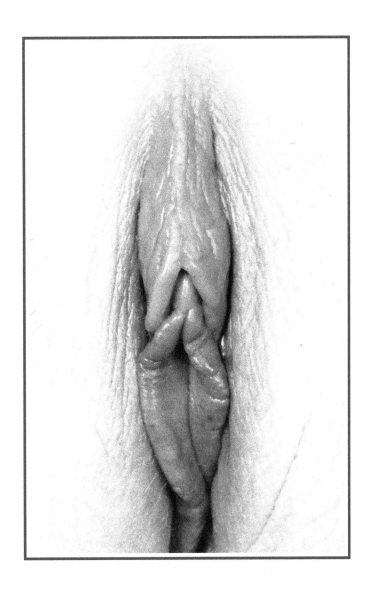

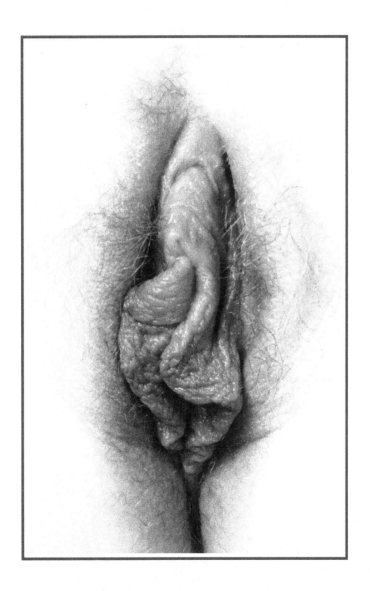

17

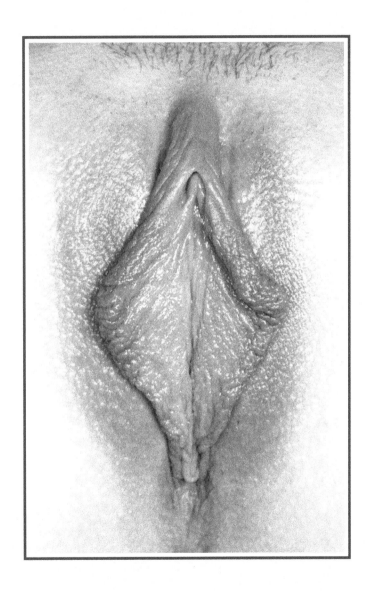

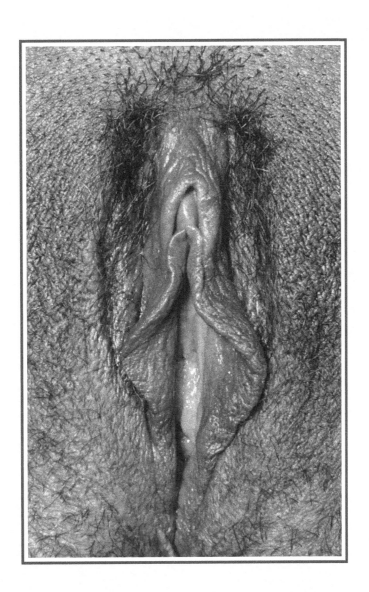

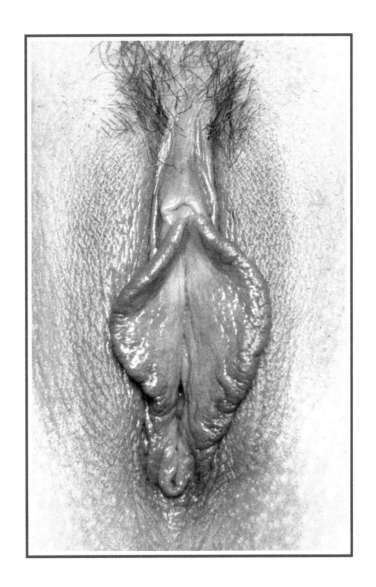

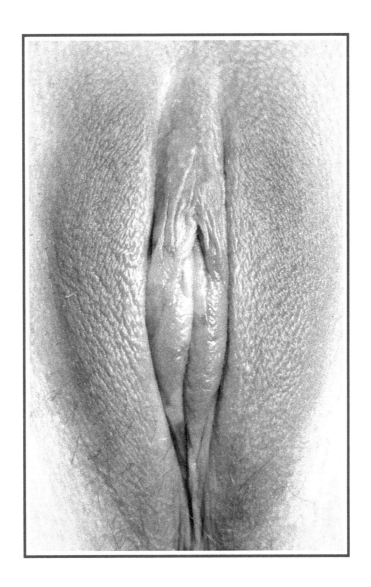

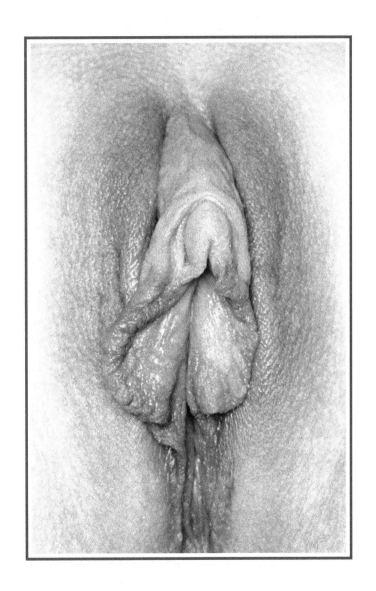

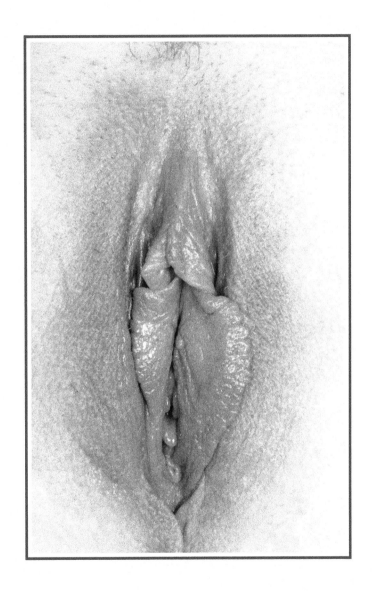

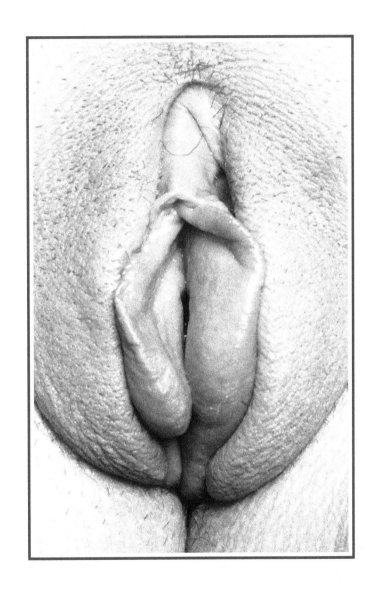

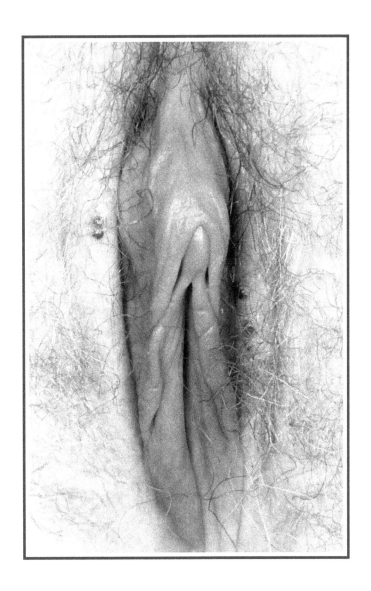

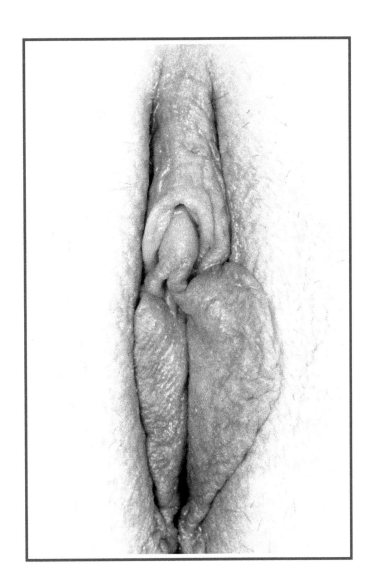

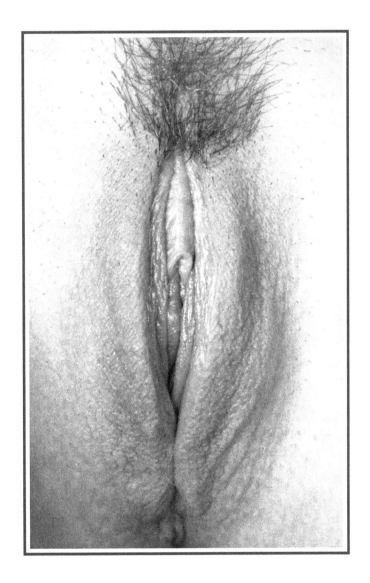

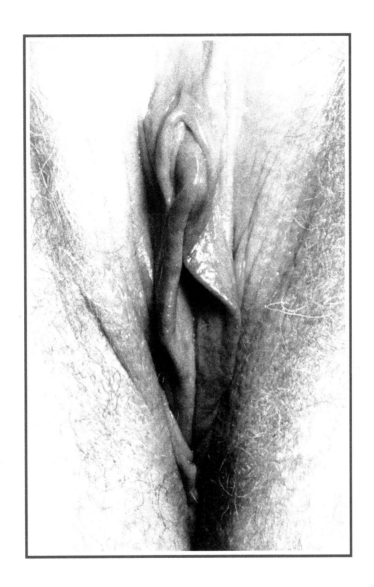

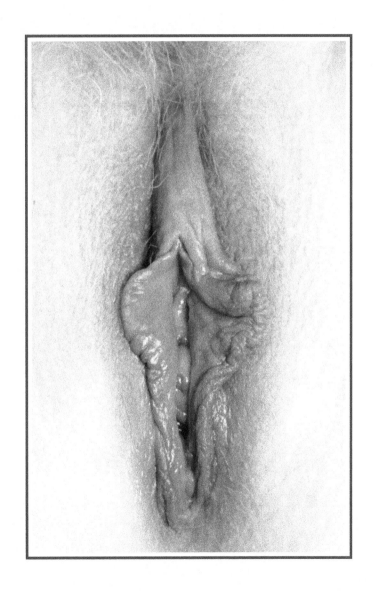

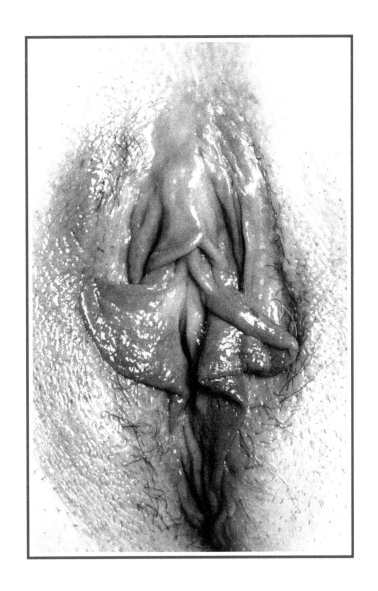

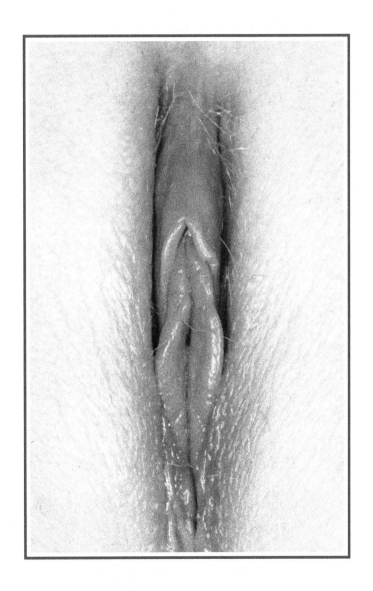

45

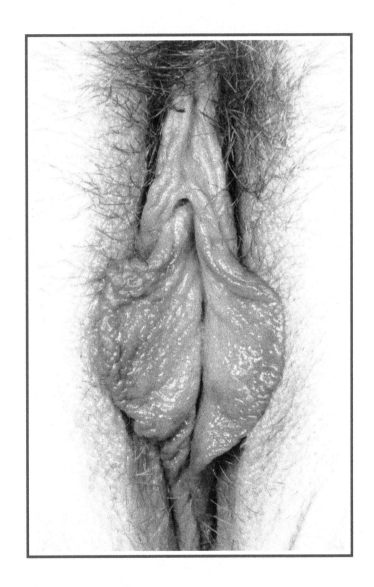

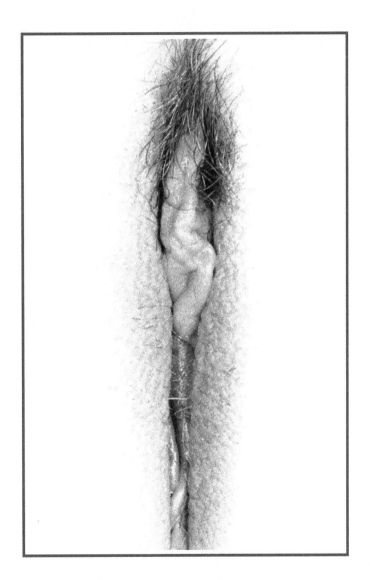

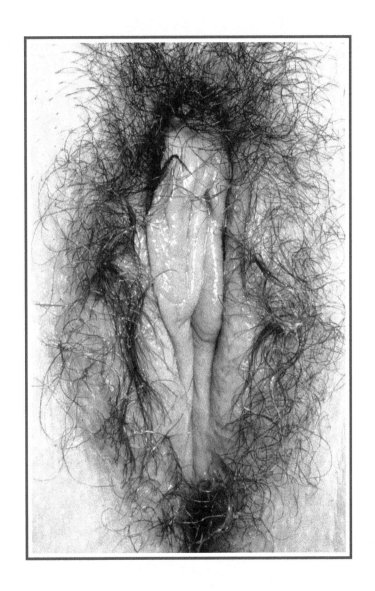

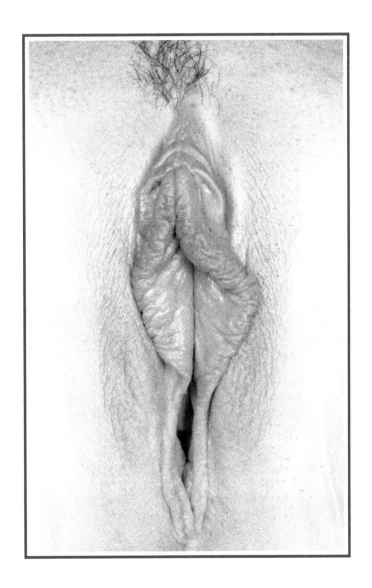

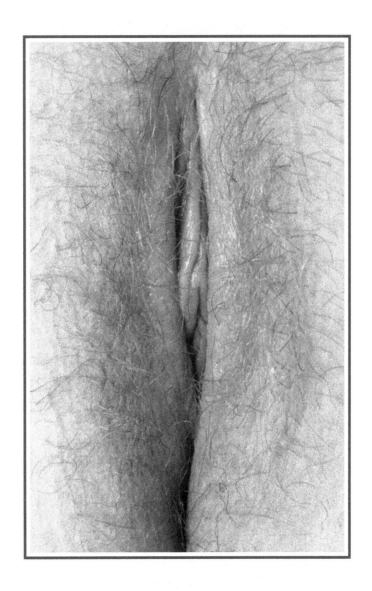

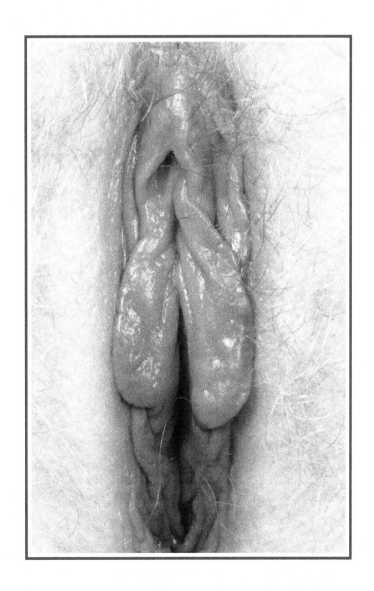

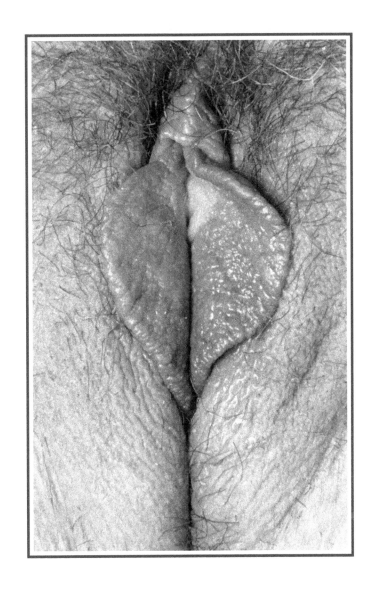

59

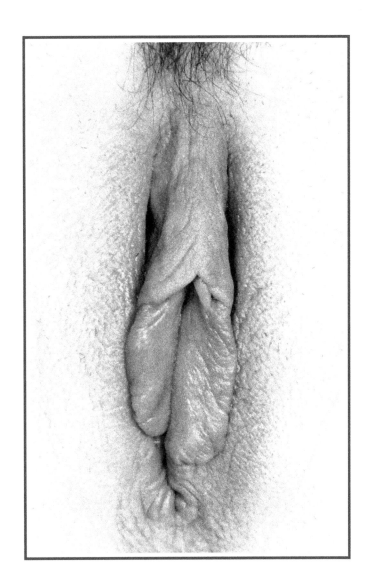

61

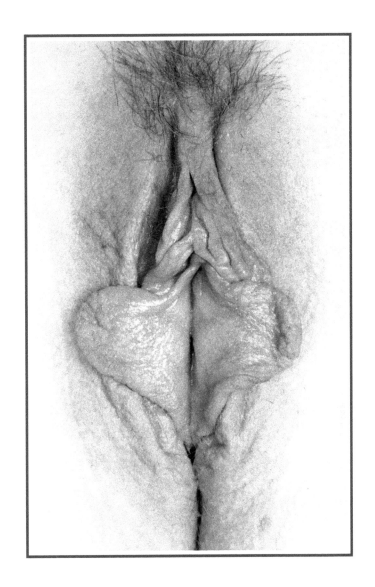

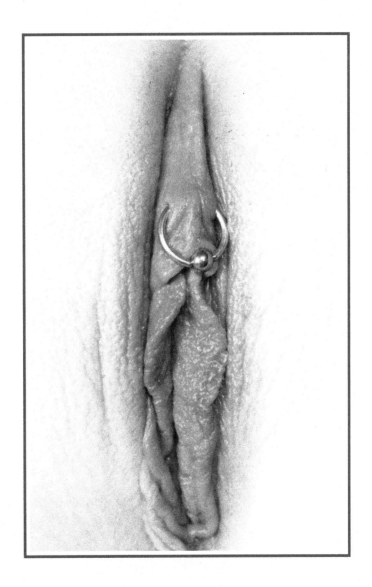

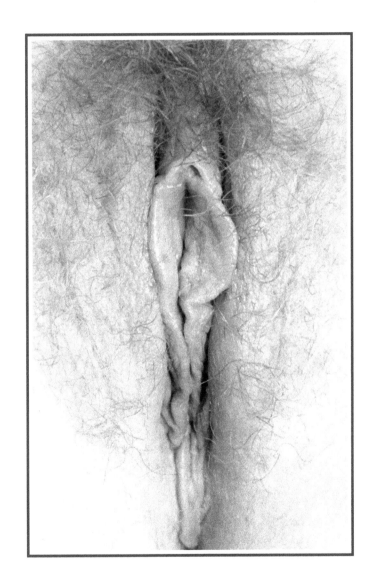

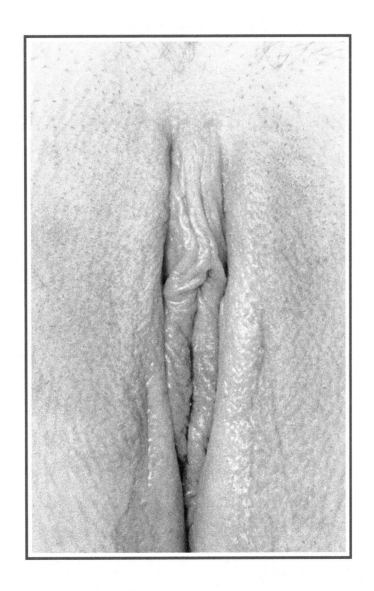

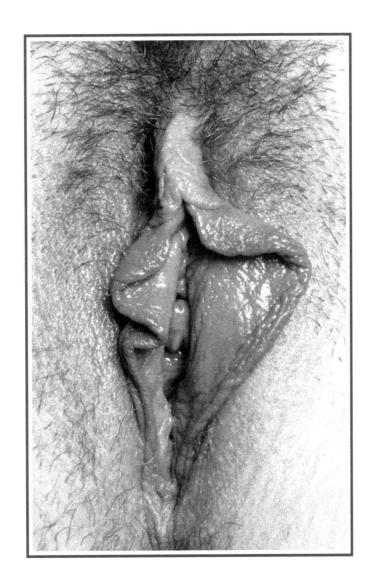

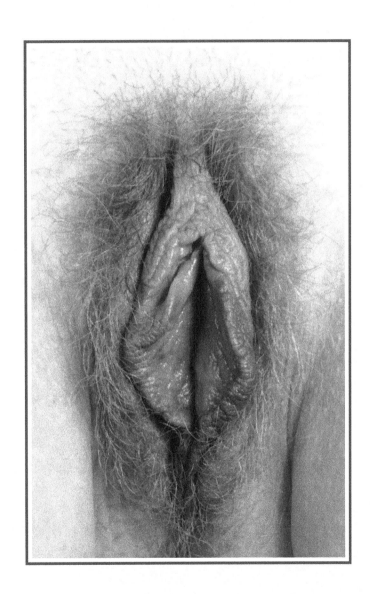

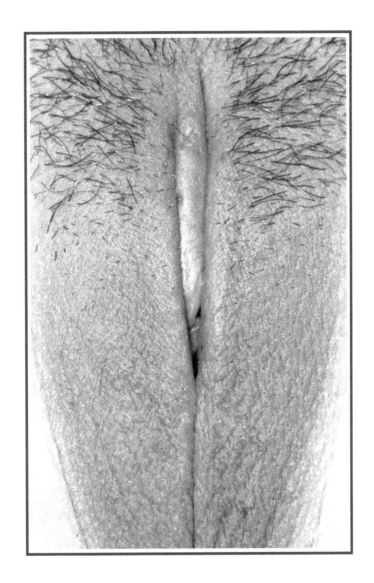

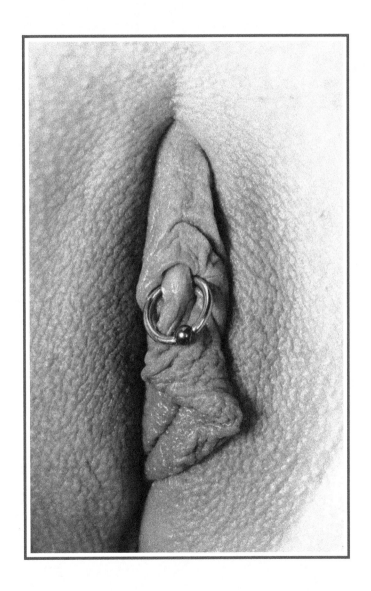

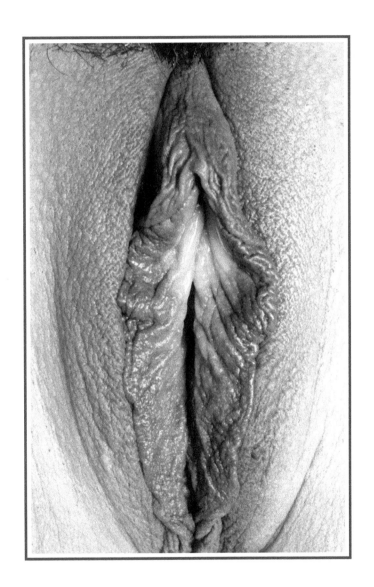

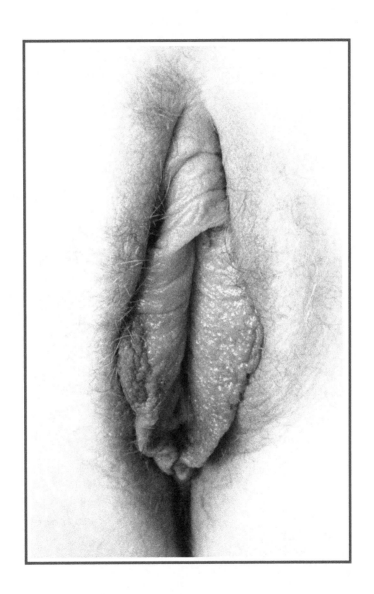

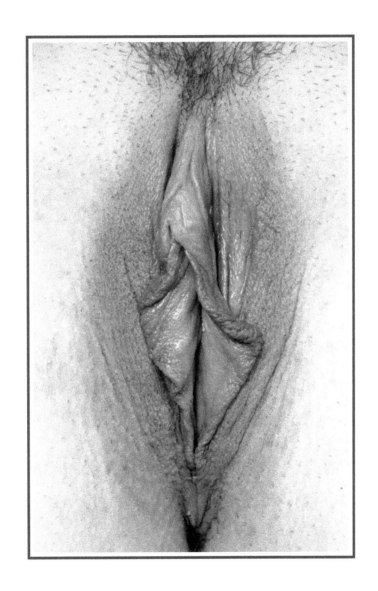

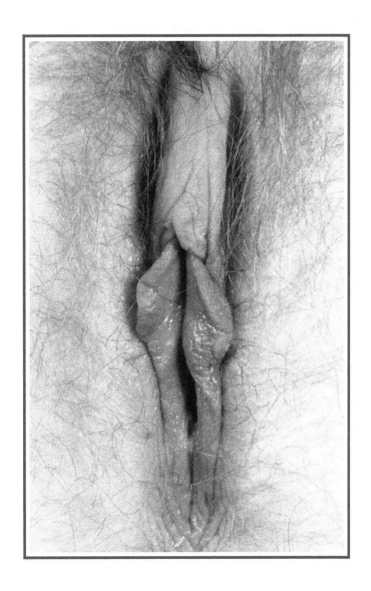

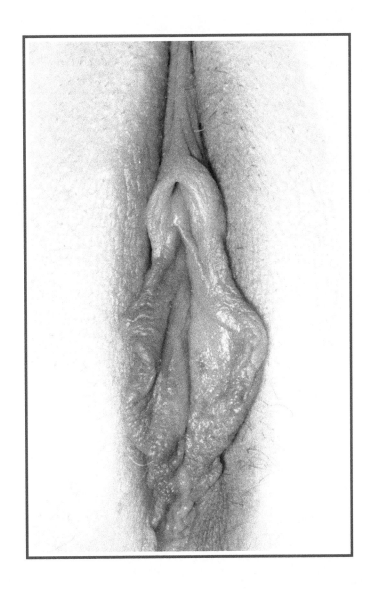

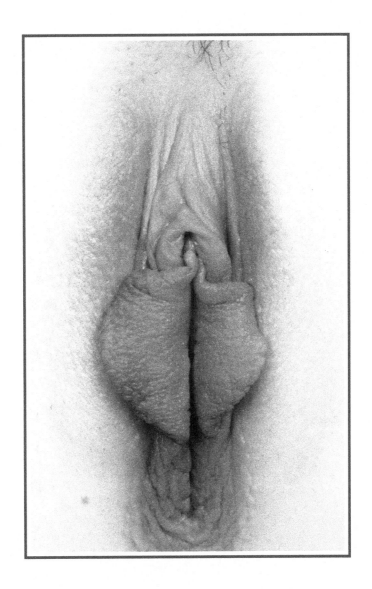

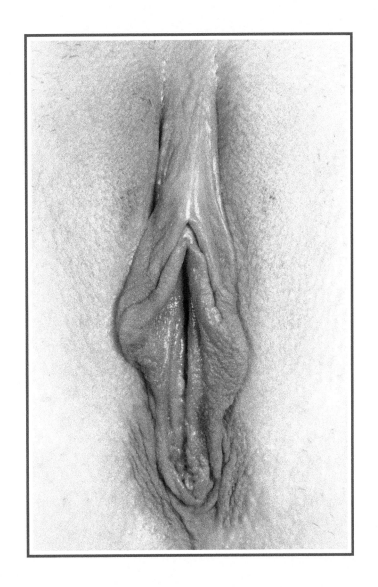

91

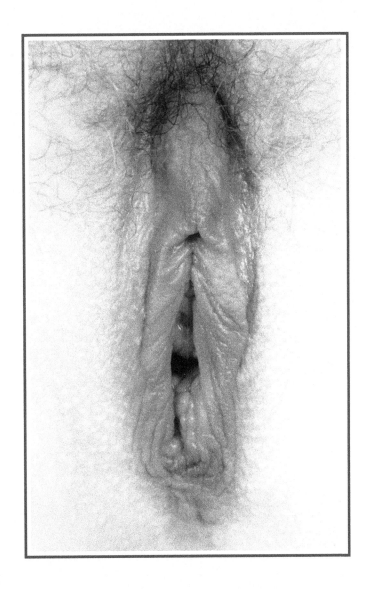

93

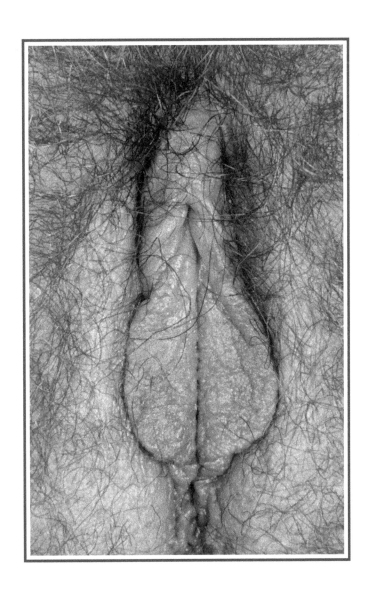

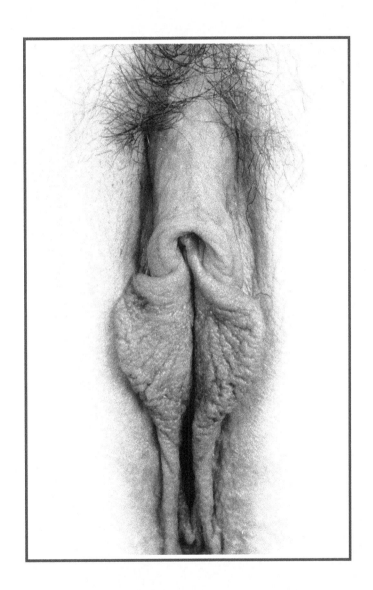

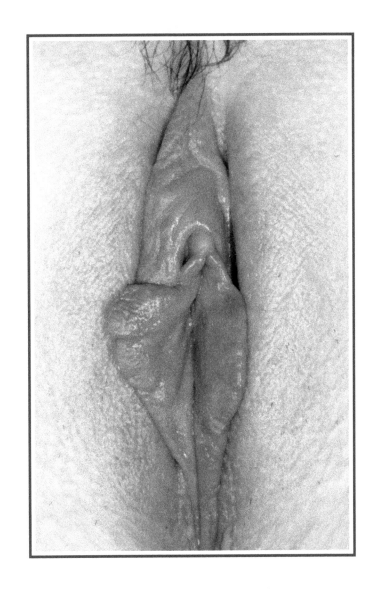

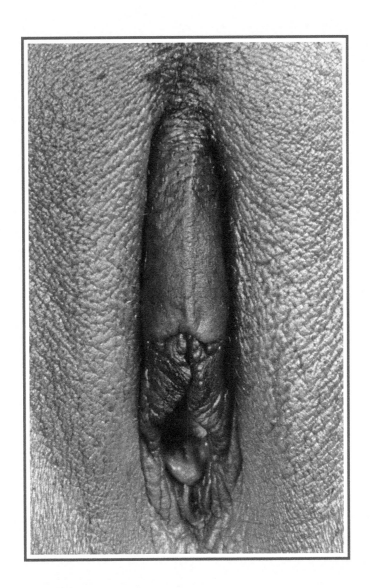

101

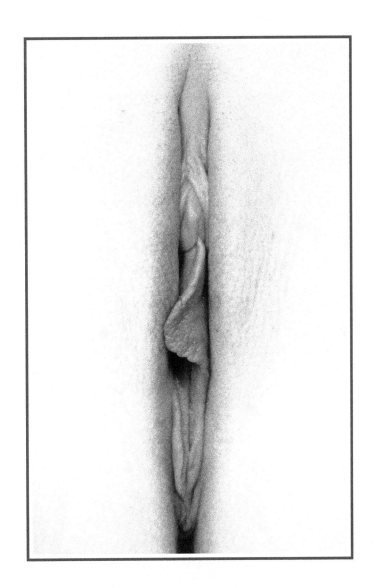

An Interview with Nick Karras

by Carol Pharo

Why the book title "Petals"?

In talking to women I photographed, few seemed comfortable with a common word referring to their vulva. Then one woman said, "it's my flower", and it dawned on me that when I looked at all of them, they looked like flowers, the petals of flowers."

These "petals" are so richly graced with color. Why did you choose to shoot this subject in black-and-white?

There's nothing more colorful than nature's landscapes. However Ansel Adams shot his mountains of Yosemite and other vistas of the West in black-and-white. And Edward Weston chose black-and–white for his nudes. Someone once said that black-and-white photography is like reading: the reader supplies the color and other sensations. That's part of its peculiar enjoyment.

Did you first experiment with color?

Yes, and I didn't like it. Depending on your intentions, color can overwhelm some images, a distraction in a way. The vulva is almost too powerful when shot in color—to me it suggests pornography. It can be too real. The viewer gets drawn into a purely sexual response to the subject. That isn't what I was aiming for here. In my research I noticed that women looking at similar material would hurry through brightly lit, full color shots of vaginas, yet they tended to slow down and study black-and-white photos. Perhaps color unconsciously registers as vulnerability, and it's scary. I suspect that one is inclined to be overwhelmed by the vibrant shades of vaginas and not pay attention to their exquisite lines and other subtle physical characteristics.

So your intent was to create a different aesthetic?

Not at the start. I discovered my motive as the work developed. There's much more depth in black and white. This mode of photography plays in the gray scale from white

to black. You use these values to create separation and depth. Black-and-white renders those qualities very strongly. When I worked on the prints, I was much more aware of the contours and composition of each woman's pussy—its solemnity.

Your work, however, is actually presented in a sepia tone.

True, I shot them with black and white film but then toned them more softly. I think that pure black and white, for this subject, is a bit harsh. Sepia is softer. This tone also creates a more suitable and thoughtful distance.

What were some intimidating issues in doing the book?

The biggest problem was creating a work that distanced itself from pornography. I found that most women didn't like seeing themselves or others in photography that looks raw. When I first started shooting, the results were unsatisfactory. I wasn't using lighting to the best advantage. But after playing with the different elements—the right paper, tone, and texture—the results were fascinating. It was a big learning curve for me.

What about criticism that argues against objectifying the female body by showing only its most private part?

The same general critique was made of a photographic show by the late Irving Penn at the Metropolitan Museum of Art. In his erotic nude series, Penn beautifully portrayed only limited angles of the female body, yet every photo conveys an essential truth about each woman photographed. There's a time, place, and situation for deconstruction. For two hours on stage in The Vagina Monologues, Eve Ensler presents women's pussies (her term) as its sole subject—not women's educational accomplishments, maternal concerns, or aesthetics of fashion. She has been applauded for her contribution to female consciousness, and rightly so.

How did this whole project start for you? What inspired you?

It's an interesting story. As an adolescent, I picked up a girly magazine and there was one very unusual picture in it—a shot from behind of a nude woman showing her vagina, one with unusually long lips. I was enchanted. I cut out the picture and carried it in my wallet

for years. It was always a sure-fire turn on for me. Eventually the faded photo finally just fell apart! But in the back of my mind I looked for a woman with that configuration from then on.

An unusual search.

I suppose so. I never found such a one until an important lover entered my life, many years later. The first time I saw her naked I was totally infatuated. But it was frustrating because I didn't feel free to compliment her on the look and shape of her pussy. I couldn't say, "Gee, you have wonderfully large lips."

Of course the reverse is not true, if a man is well endowed, a lot of women wouldn't hesitate to say, "Wow, I really love the shape and size of your cock."

So true. I felt blessed being with this lover. I was totally enamored by her full lips. But I never said anything to her. Finally I couldn't hold back my visual delight. She would emphatically indicate that this was not a subject that she wanted to talk about. Finally she told me the saddest story; when she was fifteen years old her dislike for the lips of her vagina was so strong that she called a doctor to see if he would remove them. Luckily, the doctor said, "Young lady, don't do anything. Wait for ten years and if you still feel the same way, call back." As the years went by, if a lover would make any reference to the look of her vagina, she would invariably still take it negatively.

How did she break out of that self-deprecating mode?

I soon realized that it was hard for her to envision herself as I did. So with my camera, I put my focus there. I shot a lot of what I thought was beautiful erotic photography. Every now and then, when she got a little daring I would ask her if I could show her, by means of my photography, what I saw—the unique beauty of her womanhood. It didn't work at first. I photographed her every which way, but could never capture exactly what I saw. And she liked nothing that I shot. But I stayed with it. If my art form was to have any credibility, I felt that I had to translate onto film the visual image that always struck me as something quite beautiful. One day I finally got it! I lovingly toned the photograph in the dark room and then showed the picture to her. Amazed, she smiled, "Now that's pretty,

in fact that's very sexy!" At last, she really got to see what I see.

Where did it go from there?

The simple truth is that because she was proud of the pictures of her genitals she allowed me to show them to a few select people. In letting other women and couples look at the photos, they got the idea of what I was after in my work. And so other women were eager to discover through photography what they had concealed for so long.

Was your lover a help to you in pushing the project forward?

Yes. She was my first inspiration. Her encouragement allowed me to explore the subject more fully. She always stimulated me with new ideas and gave practical help by making women feel comfortable. It turned out to be sort of an underground sisterhood.

Men have always been enamored with graphic images of a woman's body, what did women seem to discover in these images?

I found that most women are secretly very interested. It's amazing because I've shown the pictures to many who said they've never really seen another woman's vagina. Unlike guys, women rarely see what another female really looks like—except for a tuft of hair because of the very physiological location of their genitals. They really become fascinated with the variety of configurations when seen at such close range.

Is it a positive reaction?

Yes. Women love to talk about sex. And after viewing this collection, I've noticed that women become increasingly curious about each other's genitals. They either say, "Oh God, I thought we all looked the same", or they say, "Oh God, I thought I was abnormal but that one looks a lot like mine." That level of the conversation is healthy, I believe.

How did you actually arrange the photo sessions?

It varied. If the woman's husband or partner were present, I asked if he would want to be part of the process. Usually the man would welcome the situation because he knew her body so well and it felt safe. It was interesting to hear him describe the intimate sexual

geography of his lover. A caring man cherishes and, in a sense, protects that part of his woman's body. As a rule, men get lost in women. It amazes me that some women don't quite understand that.

You must have had an interesting array of shooting situations.

Every photo in the book has a different story. Actually, the women who were photographed here became my strongest advocates. Typically a woman would tell her friends at work about her night in front of the camera and they became excited, perhaps challenged, then wanted to be photographed. That's how the project gained momentum — word of mouth. It's a big step, but I've found out that almost all women love the camera. They truly seem to enjoy the attention inherent in photography.

What was the essential challenge for these women?

In these photo situations, I'm asking a woman not just to take her clothes off, but to fully expose her most intimate feminine self. But just because a woman opens her legs doesn't mean her genitals are fully expressed. When a woman is doing the routine things of life, her genitals are in neutral, so to speak. As she gets turned on, all of the vagina's hidden shapes gradually appear and take on new definition. Whatever her previous personality, it now changes. What is so interesting to me in these pictures is that women are willing to reveal themselves so honestly.

That's a pretty basic place to start.

It was a wonderful place to start. It allowed me to experiment with many photographic techniques. Even more, I learned a lot about women. Many women would freely tell me about the most basic feelings relating to their genitals. Each person had her own special language to describe, for example, the nature of her arousal and sexual satisfaction.

And each vaginal expression is different.

Absolutely, as you can see in the photos. Every woman is truly unique and, one could say, her singularity starts here.

Were there surprises for you during the project?

To be specific, I was surprised that so many women shave. Some women seem to think that hair makes their vulva unattractive. Personally, I like the variety of hair patterns; visually it's very interesting. But aesthetics of the body are always changing.

Are some photographs more interesting than others for you?

One woman I interviewed after she studied the pictures said that it's like looking at faces. It's true. There's such a distinct personality in each one. Moreover, I've come to believe that the woman who is proud of her vagina also tends to reflect that confidence in the rest of her personhood.

That's saying a lot.

True, but I have sensed that a woman's attitude toward her vagina—I mean how she feels when she actually looks at herself—gets translated into how she functions in her world. I can't prove this of course. But certainly research tells us that a healthy attitude toward sex is generally matched by a robust sense of well-being. I didn't go into this activity with any preconceived opinions, but I've come out of the experience with many new realizations about the importance of how women perceive themselves physically, especially at that special place of my camera's interest.

Nick Karras was born and raised in Appleton, Wisconsin. After extensive training and travel, he settled in San Diego, California as a commercial photographer. Early on, Karras became enamored by the unique capacity of the camera to explore the nature and essence of human sexuality. The discoveries have shaped his art and his life. In the past few years, exhibitions of erotic work by Nick Karras have been featured at galleries in Los Angeles, New York, San Francisco, Tampa, Las Vegas, Victoria, and Amsterdam. He is the producer of the companion film documentary "Petals- Journey Into Self Discovery".

Printed in the USA
CPSIA information can be obtained
at www.ICGtesting.com
LVHW070025291023
762448LV00014B/677